D1109643

THE ESSENTIAL ™

Marc Chagall

BY HOWARD GREENFELD

THE WONDERLAND
PRESS

Harry N. Abrams, Inc., Publishers

THE WONDERLAND PRESS

The Essential™ is a trademark
of The Wonderland Press, New York
The Essential™ series has been created by The Wonderland Press

Series Producer: John Campbell
Series Editor: Harriet Whelchel
Project Manager: Adrienne Moucheraud
Series Design: The Wonderland Press

Library of Congress Card Number: 00–105484
ISBN 0-8109-5815-5

On the endpapers: Detail of *The Burning Bouquet,* 1970
Collection Chagall, St. Paul de Vence, France
Scala/Art Resource, NY

Unless otherwise indicated, all works are oil on canvas

Printed in Hong Kong

Harry N. Abrams, Inc.
100 Fifth Avenue
New York, NY 10011
www.abramsbooks.com

Abrams is a subsidiary of

PHOTOGRAPH CREDITS:
Scala/Art Resource, NY: 4, 45, 49, 55, 56, 65, 82, 84, 85, 87, 88, 108, 111; Erich Lessing/Art
Resource, NY: 13, 18, 62, 86, 104; Giraudon/Art Resource, NY: 42; Art Resource, NY: 44, 57,
72, 73, 87, 95, 99, 101, 102, 105

Contents

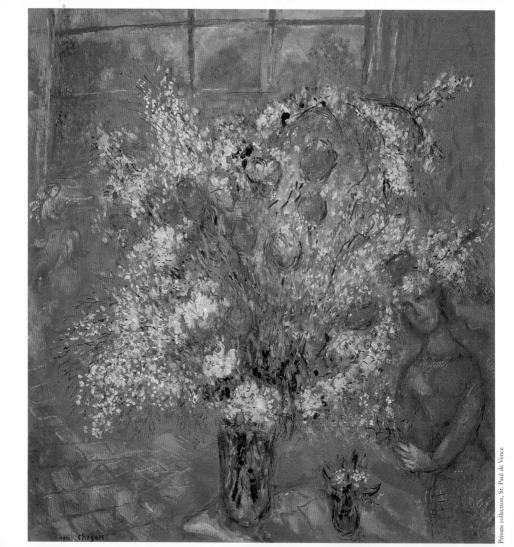

Fiddling on the roof

What do friendly roosters, frisky circus performers, lovers leaping through the air, and fiddlers on rooftops have in common? They're all part of the deliriously joyful world of **Marc Chagall** (1887–1985), the creative genius whose colorful works changed the course of pop culture and art history in the 20th century.

Chagall loved to paint and draw from the time he was a boy. But in the small Russian town of Vitebsk where he grew up, there was no one to teach him. **He had to leave his home and family to follow his dreams,** yet wherever he went—to the big cities of Russia, to Paris, New York, and Mexico City—Vitebsk and the people who lived there stayed in his mind, and in his art, through images of:

- men and women dancing on rooftops;

- horses and carriages leaping over trees;

- donkeys who wear red coats and violinists with green faces;

- brides and pairs of lovers and village characters and dazzling flowers.

The two major influences on Chagall that are key to understanding his work are:

OPPOSITE
Flowers on Red Background
1970

5

- his origins as **a young Jew born in a small Russian town**, where life in the Jewish community was deeply rooted in religion;

- his **life and art in Paris**, where he arrived in 1910, where he met the major painters and poets of the early modern period, and where he lived for many years later in his life.

From these two primary sources, Chagall developed a romantic and enchantingly naïve expression based on themes from Eastern European village life and Russian and Jewish folklore. The range and volume of Chagall's work are tremendous. Much of it is associated with literature, including his many illustrations for the Bible, the *Fables* of the French poet **Jean de La Fontaine** (1621–1695), and *Dead Souls*, by the Russian novelist **Nikolai Gogol** (1809–1852). He designed the acclaimed sets and costumes for Stravinsky's ballet *Firebird*, painted two vast murals for the Metropolitan Opera House in New York, and created 12 stained-glass windows representing the Tribes of Israel for the Hadassah-Hebrew University Medical Center in Jerusalem. Then there are his paintings.

If you don't know Chagall's work, perhaps you're wondering why it is considered great, or how Chagall has affected millions of people in countries around the world. Keep reading. You'll be amazed by his story.

Life in the village

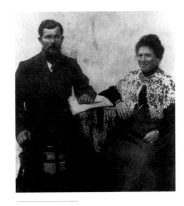

Chagall's parents,
Zahar and Feiga-Ita

And so the story begins: At the time of **Moische Segal**'s birth on July 7, 1887, no one would have predicted that the first son of **Zahar** and **Feiga-Ita Segal** would grow up to become the great painter Marc Chagall. Neither of his parents had ever shown any interest in art. As devout Jews, they paid strict attention to the Second Commandment—"Thou shalt not make unto thee any graven images"—which they believed forbade the making of pictures of human faces. Because of this Commandment, there were very few Jewish painters, and those few lived and worked in the big cities, far from where the Chagalls lived. Nonetheless, Marc became not only a painter, but also one of the best-known and best-loved artists of the 20th century.

He was born in a wooden cottage in the little Russian village of Pestkowatik on the outskirts of **Vitebsk**, near the city of Minsk, not far from the Russian-Polish border. When Marc was ten, the Chagall family moved into Vitebsk itself, a lively river port and railway junction, with a population of almost 50,000, half of whom were Jews. Marc loved to walk down its muddy, unpaved narrow streets, past its many synagogues and

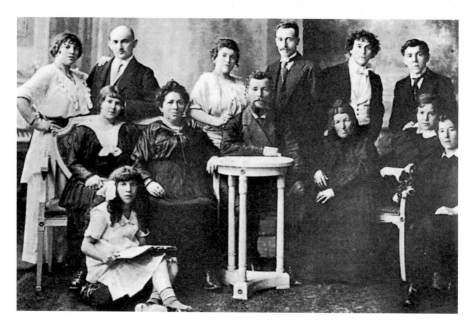

Marc Chagall (standing
second from right) with
parents, siblings, and
relatives. c. 1908

Chagall's boyhood home
Pokrovskaya Street, Vitebsk

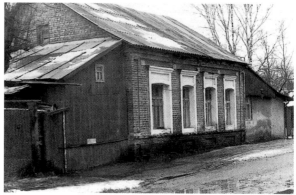

churches, its imposing 15th-century cathedral, and the rows of gray wooden buildings, many with small balconies, that housed factories and workshops of all kinds. He enjoyed gazing upward, too, at the town's skyline, the pear-shaped domes of its church towers, its corrugated rooftops and steeples and chimneys.

On the home front

The Chagall home was modest. Marc's father, Zahar, a tall, thin, bearded man, had never been and would never be a rich man. Immediately after finishing *cheder*, the Jewish elementary school, he had been apprenticed to a herring dealer, in whose warehouse he worked for the rest of his life, not as a clerk—as his own father had hoped—but as a laborer. A shy, quiet man, he had few words for his many children, but often presented them with small cakes and candied pears.

It was Marc's mother, Feiga-Ita, who sustained the family. A sturdy, energetic woman who set up and managed a small grocery store in order to supplement her husband's meager income, she also found time to be an unfailingly warm and loving mother to her children. Marc remembered her as a queen.

There were eight children in the Chagall household, six girls and two boys, but Marc—the firstborn—was Feiga-Ita's favorite, just as he was everyone's favorite. There was something special about the dreamy-eyed child with the curly hair.

The family was a large one and it played an important part in Marc's early years. It included his tiny, wrinkle-faced grandmother, who always wore a scarf around her head; his grandfather, a butcher; and **Uncle Neuch**, who read the Bible aloud every Saturday and played the violin. There were others, too: **Uncle Judah**, whom Marc described as looking like a wooden house with a transparent roof; **Aunt Relly**, whose nose was like a pickle; **Uncle Zussy**, a hairdresser; and three aunts, who, every market day, seemed to fly over the stalls with their baskets of berries, pears, and currants. He also never forgot the home in which he was raised, a home without toys but one filled with objects that gave him pleasure: the big wall clock, the *samovar* (a metal urn used to heat water for making tea), and the lamps that brightened his life.

Sound Byte:
"Our whole inner world is reality—perhaps even more real than the visible world."

—MARC CHAGALL

Not a great student

Young Marc began his education at the *cheder*, where he remained for seven years, studying the Hebrew language, the Talmud (the book of

Jewish law and tradition), and the Bible. Before long, the characters of the Bible were as real and alive to him as were the members of his family and the peasants, tailors, beggars, and bearded rabbis of Vitebsk.

At the age of 13, Marc went to public school, but he was not a good student. A dreamer distracted by his own thoughts during his classes, he enjoyed only geometry and drawing. He did so poorly in the other subjects that he was held back a year. After six years, however, as he approached the end of his formal education, he had to make an important decision: What to do with his life?

The budding artist

One day, a friend showed him an ink drawing he had made and Marc was impressed. If his friend could do it, so could he, and as soon as classes were over he went to the library to look through magazines for subjects that he might use himself. **His first drawing was a copy of a portrait of a famous Russian composer.** Soon, the walls of his room were covered with drawings. Though Marc knew that his drawings were getting better and better, no one at home took them seriously. One day, however, a schoolmate who came to the Chagall home carefully examined the drawings and exclaimed with surprise: "You're a real artist, aren't you?"

Those words marked a turning point in Chagall's life. "Artist" was a word he had never dared to use, yet it suddenly became clear to him that it was as an artist that he would best be able to express himself.

There were, however, two problems. Where would he study in order to perfect his art, and how could he convince his mother to allow him to pursue a career as an artist? The first of these was relatively easy to solve. He remembered a large sign that he often passed during his walks through Vitebsk that read: "Artist Pen's School of Painting and Design." Somehow he felt certain that artist **Yehuda Pen** (1854–1937) could teach him the techniques of painting and turn him into a real artist.

Convincing his mother—she, and not his quiet father, would have to give permission—to allow him to study painting was another matter. How could he explain to her just why he felt the need to become an artist?

He carefully chose the moment to break the news. It was morning, and his mother was alone in the kitchen putting bread in the oven, when he spoke to her of his plans. She was so shocked that she almost dropped the bread pan, and argued that Jewish boys did not become painters and that he could never make a living as a painter. But the boy persisted and his mother reluctantly agreed to discuss it with other members of the family. Predictably, most of them were horrified. But one of his uncles gave Marc's mother the courage to give in to the boy's request. "If he has talent," this uncle said, "let him try."

It was agreed that Marc's mother would accompany him to see Yehuda Pen. If Pen felt that the boy had talent, Marc could study there; if not, the boy would have to find an occupation more acceptable to his family.

Lovers Under a Red Tree. n.d.

Penning a deal

Trembling with excitement, Marc set out with his mother for Pen's studio. He carried with him a roll of tattered sketches and enough rubles, given to him by his father, to pay for his first lessons—if Pen agreed to teach him. Upon entering the large room in which the classes were held, he was overwhelmed by the sight that greeted him. Everywhere, there were piles of sketches and drawings, shelves of plaster copies of ancient Greek and Roman sculptures, and ornaments of all descriptions that would become subjects for drawing lessons and early efforts at painting. The room was covered with paintings from floor to ceiling. But the paintings on the walls were different from the paintings Marc thought he wanted to create. He instinctively felt that Pen's realistic method was not his—though he didn't yet know what his was. But he felt certain that Pen could help him find the means to express himself in his own way—if only Pen would agree to teach him. The teacher thumbed through Marc's drawings without expression, then pronounced, "Yes, he has some ability."

14

Pen's response had to be taken seriously by Marc's family. They had learned that he was one of the few Jews of Vitebsk to have studied at the great Academy in St. Petersburg, the center of all artistic activity in Russia. Besides, a deal was a deal. The boy's family now had to consent to his enrolling in Artist Pen's School of Painting and Design.

The classes at the school proved to be disappointing. Pen approached his subjects in the lifelike, accurate, realistic fashion of a photographer. Chagall's images, on the other hand, gave poetic expression to the way things looked and *felt* to him. After a few months, Chagall realized it was useless for him to continue. There was little he could learn from his kindly teacher.

His time at Pen's, however, had not been wasted. He had learned the techniques of painting—how to prepare a canvas with a layer of *gesso* (i.e., gypsum or plaster of Paris prepared with glue for use as a surface for painting), how to mix colors to obtain the desired tints and shades, how to use a palette knife to apply *impasto* (i.e., thick paint), how to use the various oils and paint thinners to keep his colors liquid, and how to clean his brushes so they would be fresh the next day.

Branching out

Moreover, Marc was able to meet and befriend other young people from a world he had never known who shared his passion for art. Chief

among these was **Victor Mekler**, a sensitive young man from one of Vitebsk's wealthier families. Understanding Pen's limitations as a teacher, Victor asked Marc to give him lessons outside of school, believing that his friend could show him things he could never learn from the older man. Marc was flattered, and he agreed.

The two spent hours together, painting and talking, at Victor's parents' home in Vitebsk and in the Meklers' spacious country house outside the city. In time, however, Victor realized that he had learned all he could in Vitebsk. He informed Marc that he had decided to move to the great capital city of St. Petersburg, about 300 miles to the north, to continue his studies, and he urged Chagall to join him.

Marc knew it was a wonderful idea, but he was understandably afraid. A move would mean having to give up a job he had held for some time as an apprentice to a photographer, where his duties consisted of retouching photographs, correcting mistakes, and removing blemishes.

The work bored him, but in doing it he was acquiring a skill that would enable him to make money in the future. Yet none of this mattered; security was of no importance to the determined young man. He wanted to become a painter and not a photographer, no matter how uncertain the future.

Off to St. Petersburg

Nonetheless, the risks he faced in moving to St. Petersburg were enormous. Above all, there was the very real chance of starvation. Unlike Victor, Marc had no rich family to support him while he studied. In fact, all his father could give him was a small sum that would last only for a short time. He would quickly have to find a way to earn money in order to survive.

Equally difficult was the problem of obtaining official permission to remain in St. Petersburg. Under the rule of the Czars—the emperors who governed Russia—Jews were treated harshly. They were considered outsiders who needed special authorization to live in the capital. (The legendary figure of the eternally wandering Jew is captured in *Ahasver*, one of Chagall's Vitebsk-inspired works from 1914–15.) Although permitted to settle in the provinces, in towns like Vitebsk, they were not allowed to live in major cities without fulfilling certain requirements. Because of this, the necessary permits were difficult to obtain and were usually granted only to members of certain professions— doctors and lawyers, for example. But in special circumstances, a merchant in a provincial town could delegate someone to do business for him in St. Petersburg for a short period of time. Under this ruling, Chagall's father was able to obtain, from a shopkeeper friend, a temporary certificate stating that Marc Chagall had been commissioned to bring goods for him to and from St. Petersburg.

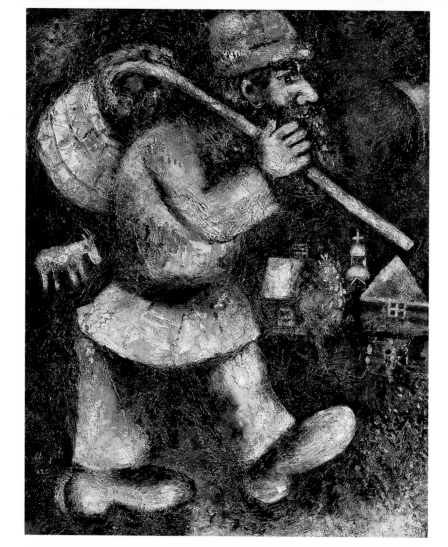

An artist trains

Provided with a temporary permit to enter the city, the 19-year-old Marc Chagall arrived in St. Petersburg in the winter of 1906–7. The contrast between his hometown of Vitebsk and the great city was enormous. St. Petersburg at the time was the capital of all Russia (Moscow became the capital in 1918) and was one of the world's great cities. It was alive with art, music, and theater.

Chagall's three-year stay there was rewarding, but his first months were difficult. His father's gift was used up in short order, and he was able to earn only a small amount of money, again working as a photo retoucher. He was often cold and hungry. He depended on the kindness of some wealthy art patrons he had met through Yehuda Pen and through Victor Mekler, one of whom gave him a small allowance for a few months. But this hardly sufficed.

Furthermore, finding a place to live, and keeping it, was a continuing concern. He was forced to share quarters with others. An equally disturbing problem during the first part of his stay in the capital was obtaining legal permission to remain there permanently. The authorization that had been arranged by his father was good for only a few months and could not be renewed. Hard as he tried, every other attempt to obtain a permit failed. Once, upon returning to St. Petersburg from Vitebsk, where he traveled often, he was jailed for trying to enter the capital without a permit. Out of jail, he realized that his only hope was

to learn a profession that would qualify him for status as a permanent resident. His search led him to a sign painter who needed an apprentice-assistant, but after months of hard work, Chagall was unable to pass the final examination that would have qualified him to work and thus entitle him to the necessary permit.

Sound Byte:

"When I work from my heart, almost everything comes right, but when from my head, almost nothing."

—MARC CHAGALL

Chagall became desperate. He knew that he had to remain in St. Petersburg in order to grow as an artist. Yet he was unable to do so legally, and he could not risk going to jail again. Just when all seemed hopeless, however, he met a kindly and wealthy lawyer named **Goldberg**, who proved to be his guardian angel. Goldberg was not only a patron of the arts who admired Chagall's talent, but he also offered the young painter a solution to his practical problems. As a professional, the lawyer was permitted to hire Jewish servants and offer them a place to live in his own home, as well as obtain permanent residence permits for them. No one could prevent him from "hiring" Chagall and allowing him to live in the Goldberg residence. He couldn't offer Marc a real room of his own—only a bed in a small alcove under the stairs, but it was enough.

Whew!

Chagall finally had a home and was legally permitted to remain in St. Petersburg. Goldberg and his family introduced the young painter to their friends, and they bought some of his drawings in order to encourage him. With Goldberg's assistance, Chagall was soon accepted by a school sponsored by the Imperial Academy for the Protection of the Arts, created for students who had failed to gain admission to the Academy. His work attracted the attention of the school's dynamic new director, **Nicholas Roerich** (1874–1947), a painter, poet, and archaeologist who rewarded the young man by granting him a small scholarship.

In spite of this, Chagall was unhappy. Although most of his teachers praised him, Marc felt that his time spent in the school's damp classrooms was wasted. Finally, in July 1908, after being ridiculed by a teacher who did not appreciate his work, he abruptly left the school.

Marc Chagall, 1908

The Svantseva School

There was one last hope in his search for a congenial place to learn his craft. Through Goldberg, Chagall had

met many art collectors, several of them active in efforts to promote a rebirth of Jewish culture in Russia. One who had recognized his talent was **Leopold Sev**, the editor of an important Jewish cultural magazine. Through Sev, Chagall first heard of **Léon Bakst** (1866–1924) and his classes at the Svantseva School. The Svantseva was a different kind of art school, the most liberal in Russia, and the most open to—and influenced by—the new ideas of modern art that were sweeping through Western Europe.

Armed with a letter of recommendation from Sev, Chagall arrived at Bakst's home. Their first meeting was successful. Bakst, whose origins were as humble as Chagall's—he had come from a small town not far from Vitebsk—was a friendly man and responded with encouragement. He agreed to admit Marc to the school.

It didn't take the young artist long to realize that this new school was unlike any he had attended in the past. The teachers challenged him as he had never been challenged before, and the other students were on a higher level than those with whom he had studied before. The program consisted of classes in painting and drawing. The students would work all week, and on Fridays Bakst would come to see their paintings and comment on them, showing no pity as he pointed out their faults. The first Friday, Bakst studied one of Chagall's efforts, then made harsh and unsympathetic remarks. Understandably, Chagall was upset—no one had ever judged him in such terms. The following Friday, however,

was even worse, for Bakst passed by Marc's work in silence, as if it were not worthy of comment.

This was too much. Doubting his ability to take advantage of what Bakst had to offer, Chagall decided to leave school and work on his own—until he felt ready to return. It was a difficult period of self-evaluation, during which he painted day and night. After three months, he returned to the school, confident enough to subject himself once again to Bakst's criticism. His confidence was justified. On the first Friday following his return, Chagall showed his latest work to the teacher. This time, the latter was so pleased that he hung the painting on the wall of the studio.

While studying at the Svantseva School, Chagall saw his work improve and Bakst was impressed by his progress. Marc was influenced by his first exposure—in printed reproductions—to the colorful paintings of **Paul Cézanne** (1839–1906), **Vincent van Gogh** (1853–1890), **Paul Gauguin** (1848–1903), and **Henri Matisse** (1869–1954), artists who were changing the course of art history with their bold new approaches to painting.

Sound Byte:
"What I like about him is that after listening closely to my lessons, he takes his paints and brushes and does something absolutely different from what I have told him."
—LÉON BAKST, Chagall's teacher at the Svantseva School

Bring on the colors!

Chagall was gradually developing a style of his own, using increasingly vivid colors instead of muted shades to portray his subject matter. Two examples of his earliest masterpieces include the hauntingly powerful *The Dead Man* and the gently poetic *Russian Wedding.* He was also, with good reason, beginning to take himself seriously as a painter. His *Self-Portrait with Brushes*, painted in 1909, shows the 22-year-old Chagall as he saw himself then: undeniably and assertively a painter, with a traditional beret on his head and three brushes in his hand, radiating a mysterious smile of self-confidence.

Sound Byte:
"One must quench the richness of color with one's soul."
—MARC CHAGALL

Love is born

Most of Chagall's early paintings are autobiographical. The town of Vitebsk remained forever a part of his universe, and during his three-year stay in the capital he often visited and spent long periods there. One such visit, in the autumn of 1909, was of special importance, since

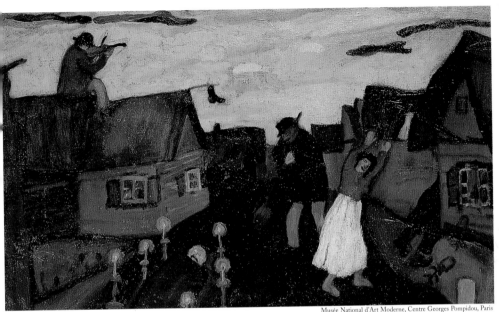

it was on this occasion that he met **Bella Rosenfeld**, the first love of his life. During his visits home, Chagall spent more and more time with new friends—not those of his early childhood, but those he had met through Victor Mekler: young intellectuals enthusiastic about the world of art, music, and literature. Among these was **Thea Brachman**, the daughter of a wealthy physician. Chagall liked Thea and spent many hours at the Brachman home. It was there that Chagall met Bella, the youngest daughter of one of the richest families of Vitebsk—

Detail of
The Dead Man
1908
26 ⁷/₈ x 33 ⁷/₈"
(68.2 x 86 cm)

25

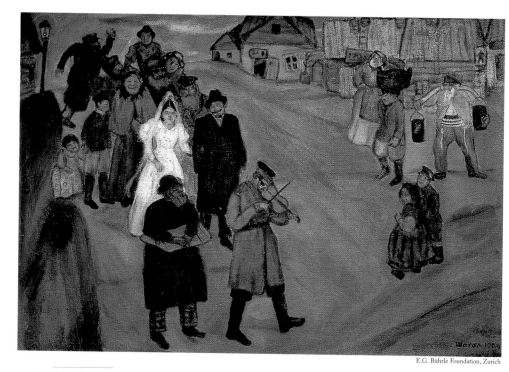

Russian Wedding
1909. 26 ³/₄ x 38 ¹/₄"
(68 x 97 cm)

her father owned three jewelry shops. She was an aspiring actress who was studying at one of the best girls' schools in Moscow. When they met, it was love at first sight for both of them.

Sound Byte:
"Her pale coloring, her eyes, how big and round and black they are! They are my eyes, my soul.... I know this is she, my wife."
 —MARC CHAGALL, in *My Life,* on meeting
 Bella Rosenfeld for the first time

Following their first meeting, Marc and Bella saw each other frequently. They shared each other's thoughts and feelings as neither had ever done before. They were both shy, and in the beginning they held their meetings in secret. Before long, however, it didn't matter who knew about them. They were in love. Each time Marc came to Vitebsk for a visit, it was Bella he sought first. She inspired and encouraged him.

When Marc proposed marriage, Bella accepted joyously. Her family, however, was not pleased. The Rosenfelds and the Chagalls belonged to different classes. The Rosenfelds lived in a beautiful home with servants.

Bella Rosenfeld. 1917

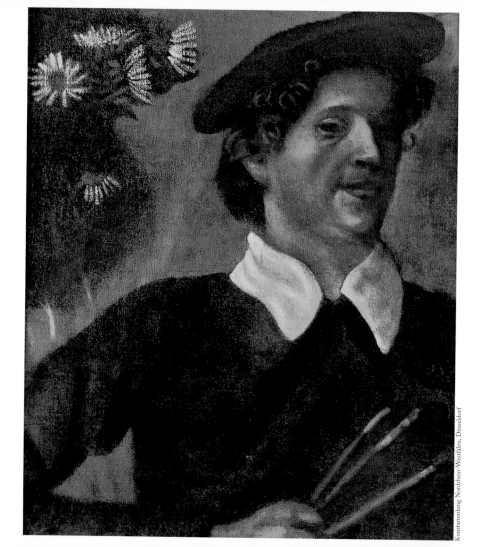

Their daughter, Bella, was not only beautiful, she was also brilliant. How, they wondered, could such a distinguished child even consider marrying a young man from a poor family whose only desire was to become a painter?

None of this mattered to the young couple. They knew they belonged together, and they knew they would someday wed. But they also knew—given her family's objections—that they would have to wait until Marc had proven himself and made his way as a painter.

Faces galore

Some of Chagall's most memorable paintings were the portraits he made of the townspeople of Vitebsk; rabbis and musicians; strikingly perceptive portraits of family members; and a number of revealing self-portraits, which most effectively traced his progress and attitudes as an artist. None of his portraits, however, were more loving and affectionate than those he painted of his beloved Bella throughout her lifetime. *Portrait of My Fiancée in Black Gloves* remains among the finest. He painted it the summer after they met in Vitebsk; she was already his muse and would remain so for the 29 years they were married, until her death in 1944.

It is a rather surprising picture for a romantic young man of 22, in love for the first time, since the young woman stands somewhat stiffly, hands on her hips, her face unsmiling. She wears a white dress with a

ruffled collar, adorned by a single pin. The whiteness of her form-revealing dress contrasts sharply with the black background, the blue beret, and those black gloves. At first, it might seem that Bella is cold, but as the viewer examines the portrait more closely, it becomes obvious that the artist saw his beautiful fiancée as an intelligent, determined, and willful young woman, unusually mature for her years. As a student actress, Bella was attending lectures by the great **Konstantin Stanislavsky** (1863–1938), director of the Moscow Arts Theater. This most likely accounts for her formal theatrical pose.

Off to Paris

In 1910, Chagall took a giant new step. Certain that his art could not grow and flourish in Russia, where true artistic experimentation was discouraged, he decided to leave St. Petersburg for Paris, the vital center of the world of modern art. He had long considered such a move. Then his teacher, Bakst, announced his own intention to leave for the French capital. He had been summoned to work as a scenic designer for the great impresario **Sergei Diaghilev** (1872–1929), whose ballet company was showing the world the glories of Russian dancing. Chagall, too, opted to make the move.

Sound Byte:
"My art needed Paris like a tree needs water."
—MARC CHAGALL, on his decision to move to Paris in 1910

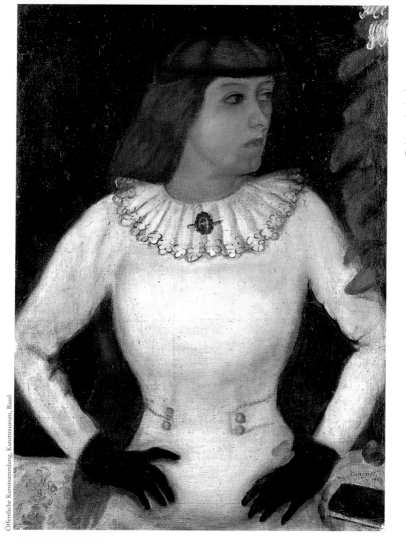

Portrait of My Fiancée in Black Gloves. 1909
53 ¹/₂ x 55 ³/₄"
(131 x 136.5 cm)

It was a difficult decision that required both courage and money. Chagall had much of the former and little of the latter. But he persisted, searching for a sponsor who might make the move to Paris possible. Before long, he found one, **Maxim Vinaver** (1862–1926), a distinguished lawyer and member of parliament, and Leopold Sev's brother-in-law. Vinaver believed in Chagall and his art, and promised him an allowance that would enable him to live in Paris.

Sound Byte:
"My father put me into the world; Vinaver made a painter of me. Without him, I would probably have remained a photographer in Vitebsk without any idea of Paris."
—MARC CHAGALL, in *My Life*, on his benefactor Maxim Vinaver

In the summer of 1910, as he prepared to leave Russia behind him, the young artist was nervous. He left behind his hometown and family. And he left Bella, certain that their love would endure. He gathered all of his possessions and paintings, and boarded the train for the four-day journey to Paris.

Rebirth in the City of Light

Chagall felt lost when he arrived in Paris in August 1910. He was confused by the traffic and the masses of people, all speaking a language

he barely understood. He was overwhelmed by the brilliant colors and lights, so different from the drab grayness of his hometown. Before long, however, he had a chance to visit the city's magnificent museums and galleries, and no longer felt alone. He came to realize that Paris was his second Vitebsk, his second birthplace.

He felt most at home at the Louvre, the magnificent art museum along the River Seine. As he studied the paintings of the great French masters—**Eugène Delacroix** (1798–1863), **Gustave Courbet** (1819–1877), **Jean-Antoine Watteau** (1684–1721), **Jean-Baptiste-Siméon Chardin** (1699–1779)—he felt as if he were visiting old friends who gave him the strength and courage to continue his struggle to become an artist. Though he was to study from time to time at various Parisian art schools, it was from seeing the works of Cézanne, Matisse, **Pablo Picasso** (1881–1973), and **Georges Braque** (1882–1963) and, even more, from experiencing the city of Paris itself that the young man learned his lessons. The light of the city, as felt by him during his first years in the French capital, would soon shine through his work and intensify his colors.

Sound Byte:
"I was very dark when I arrived in Paris. I was the color of a potato. Paris is light."

—MARC CHAGALL, upon his arrival in Paris in 1910

Thanks to the allowance given to him by Vinaver, Chagall was better off than most struggling artists. Starvation and homelessness were never serious threats during the years he lived in Paris (1910 to 1914), yet times were difficult, especially during his first months. Sometimes he lacked money to buy new canvases, but nothing could stop him from working. He would buy old paintings, which cost less than fresh canvases, and paint over them.

Chagall's first home was ideally located in Montparnasse, the lively section of the city that housed most of its artists and writers. At its center were two famous cafés, the Dôme and the Rotonde, meeting places where, around crowded tables, drinking coffee or wine, German and Russian and American and Polish painters would join their French colleagues in stimulating discussions of the latest trends and movements in art. Chagall enjoyed observing these encounters, but he rarely joined in. Much as he loved to paint and much as he appreciated great painting, **he rarely liked to talk about his art**. He had no theories or rules. *Painters have always been mad, he felt, and there was no reason to expect them to talk sense.*

He got to know the important artists and writers of Paris, learning and profiting from his meetings with them. He would form a lasting friendship with the artists **Robert Delaunay** (1885–1941) and his wife, **Sonia Delaunay** (1885–1979). On Friday evenings, he regularly went to the home of **Ricciotto Canudo** (1879–1923), the editor of an

avant-garde magazine whom Chagall would cite in *Homage to Apollinaire* (see page 43).

All the buzz

Even more opportunities to become acquainted with artists like himself came in the winter of 1912 when Chagall moved into a 12-sided building known as **La Ruche**, or The Beehive. Founded at the turn of the century by a little-known sculptor whose dream had been to establish inexpensive lodgings and studios for impoverished artists, La Ruche is today remembered as a cradle of modern art. Chagall's studio—one of 140 in the complex—was on the top, or second, floor of the main building. The neighboring studio was occupied by **Amedeo Modigliani** (1884–1920), a young Italian who would later be recognized as one of the most important artists of his time.

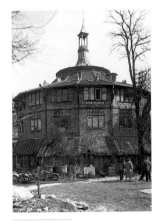

La Ruche
(The Beehive), Paris

La Ruche was a center of social activity as well as a place to work. The artists sang together, recited poetry, and played guitars throughout the night, often loudly. They discussed art, politics, and the meaning of life until sunrise. But Chagall was a loner. While the others enjoyed themselves, he remained in his room, working feverishly by the light of a small kerosene lamp.

Chagall's friends and neighbors considered him a strange "poet," whose treatment of themes set him apart from his fellow artists. His works, often expressing memories of Russia, its folk heritage, and his own childhood, were dreamlike: lovers or cows or donkeys or fish defying gravity and logic by floating miraculously in the air.

Sound Byte:
"Color and line contain the artist's whole character and message."
—MARC CHAGALL

I and the Village

Everyone began to notice, too, his imaginative use of color. Even his former teacher Léon Bakst agreed, after a visit to La Ruche, that his pupil's colors "sang." He painted in rich primary colors his memories of Vitebsk and his childhood there in such works as *The Soldier Drinks* and *I and the Village*. The latter is one of the artist's best-known works. It is a marvelously rich evocation of his hometown, a foreshadowing of many of the themes—the peasants, flowers, cows, churches, and farmers—that would haunt him for years. It is Chagall's love for his hometown seen with the new vision and techniques acquired in Paris. It is, as are many of his works painted during this period, a work influenced—but not constrained—by **Cubism**, the movement that had

originated around 1907 with Picasso and Braque, and in which artists reduced objects, figures, and even landscapes to their basic geometric forms and presented them as such on canvas.

The painting is made up of interweaving circles and triangles. A wide-eyed, smiling peasant with a green face and a cross hanging from his neck, who dominates one side of the painting, faces the head of a large cow, which wears beads around its neck. The peasant's hand—there is a red-jeweled ring on one finger—holds a sprig of flowers, which almost reach the mouth of the cow, which dominates the other side of the painting. Nothing is realistic: A scene of a maid milking a cow is superimposed on the head of the large cow; on the top of the canvas, there is a row of small houses—two of them upside down—as well as a church, with the oversized head of a priest framed in it. Just below the town, we find a farmer with a scythe, next to a female companion,

The Solomon R. Guggenheim Museum, New York

The Soldier Drinks
1910–11. 44 ¹/₂ x 38 ¹/₂"
(109.1 x 94.5 cm)

standing on her head. The more we examine *I and the Village*, the richer we find it. One critic argues that the green-faced man is thinking of his sweetheart milking a cow as he looks at the cow's head. That perhaps explains the milkmaid in the cow's head. It must be remembered that Chagall was a poet-painter who believed that it was as much an artist's right to do what he/she wished with images as it was a poet's right to use words in any way he/she desired.

Sound Bytes:

"I fill up the empty space in my canvas as the structure of my picture requires with a body or an object according to my humor."

—MARC CHAGALL

"Every poet has the right to say that a swallow soaring up to the sky is a dagger. Should we painters not also have the right to paint a dagger instead of a swallow?"

—GEORGES BRAQUE, French artist,
on the liberties of artistic expression

Important friendships

Given the poetic quality of his paintings, it is not surprising that Chagall's genius was first recognized by poets rather than by painters. Nor is it surprising that during the four years he spent in Paris, two of

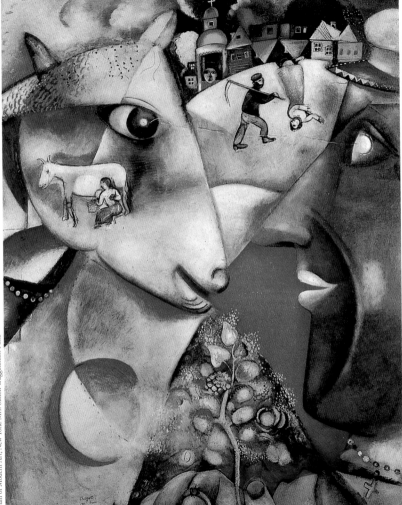

his most important friends were the daring and innovative poets **Blaise Cendrars** (1887–1961) and **Guillaume Apollinaire** (1880–1918). The Swiss-born Cendrars was perhaps Chagall's closest friend during those years. The two spent hours together and the poet provided Chagall with the titles of several his paintings, among them *I and the Village*.

Chagall's relationship with Apollinaire was less intimate but of greater importance to his career, because the Symbolist poet was not only one of the leading literary figures of the period, but also one of France's most influential art critics. Apollinaire was a spokesman for and defender of Cubism. Of course Chagall, to whom color and fantasy were of the greatest importance, was no Cubist. Nonetheless, Apollinaire was moved by the young Russian's paintings, his sense of humor, and his unique poetic vision of the world. He became Chagall's loyal supporter.

Sound Byte:
"He is an artist of enormous variety…not encumbered by allegiance to any theory."

—Guillaume Apollinaire, French Symbolist poet
and art critic, on Chagall

Paying tribute

Also in 1911, Chagall created the turbulent, disturbing, explosively erotic work *Dedicated to My Fiancée*, painted in bold reds, greens, and gold. The censors of the Salon des Indépendents (i.e., the stalwarts of the Parisian art establishment), where it was first exhibited, asked that the work be withdrawn on the grounds that it was pornographic—that the oil lamp was a phallic symbol. After the artist made a minor adjustment by adding a touch of gold to the offending lamp, the censors backed down.

The mysterious, rather puzzling *Homage to Apollinaire*, painted between 1911 and 1913, is considered unique among Chagall's paintings for its harmonious organization of forms and for the clarity of its allegorical message. A heart, pierced by an arrow, lies at the bottom of the canvas; around it, one sees the names of four men, all of whom were important to Chagall's career: Apollinaire, Cendrars, Canudo, and **Herwarth Walden** (1879–1941), the German dealer who gave Chagall his first important exhibition, in Berlin.

Though the poets appreciated him, the public failed to respond to Chagall's art during these years in Paris. Since he was a follower of no particular school of painting, his paintings did not fit into any of the currently fashionable classifications—and did not sell.

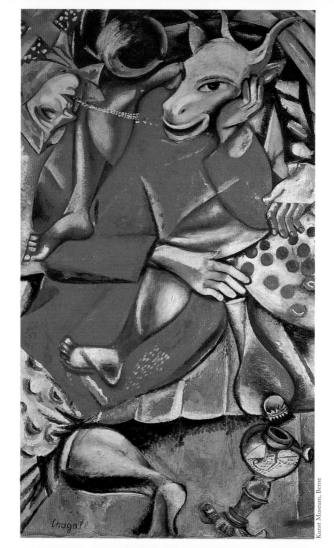

RIGHT
Dedicated to My Fiancée
1911
83 $^7/_8$ x 52 $^1/_8$"
(213 x 132.4 cm)

OPPOSITE
Homage to Apollinaire
1911–13. Oil, gold and silver powder on canvas
78 $^3/_4$ x 74 $^5/_8$"
(200 x 189.5 cm)

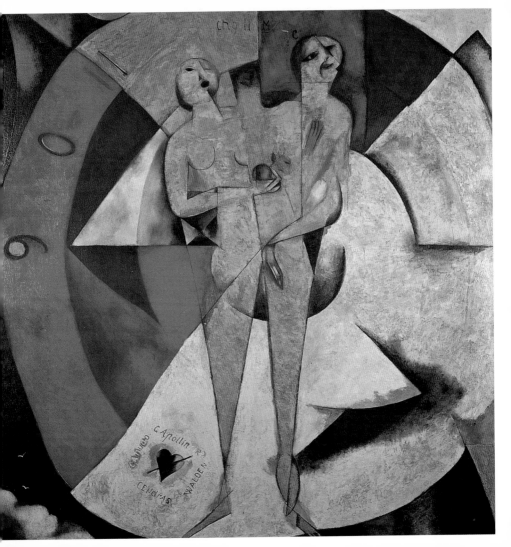

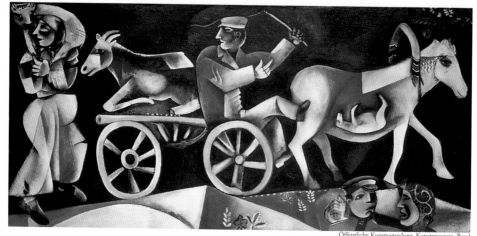

Words, words, words

The Cattle Dealer
1912. 38 x 79"
(97 x 200.5 cm)

In 1912, Chagall created one of his earliest of many portraits of rabbis, *The Pinch of Snuff.* Here, letters and words are of special importance. The Star of David in the background holds the letter that means "death," while the words on the pages of the open book, on the table in front of the rabbi, though clearly Yiddish, are hard to decipher—except for the name of the painter, which can easily be read.

In his autobiography, *My Life*, Chagall wrote that he had forgotten to remember his Uncle Neuch. "With you, I used to go out in the country to look for cattle. How happy I was when you consented to take me with you in your jolting cart." In 1912, he recalled these visits to the country in *The Cattle Dealer*, which can be viewed as a symbolic

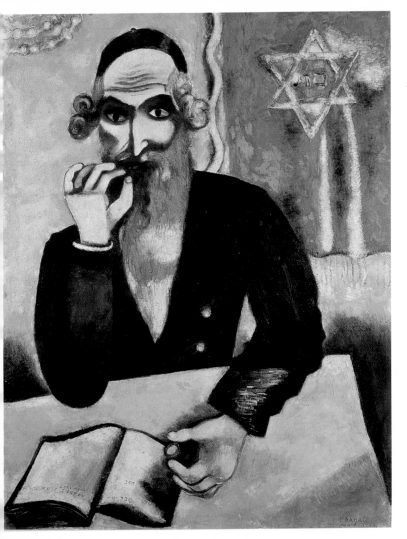

The Pinch of Snuff. 1912
46 x 35 ¹/₄"
(117 x 89.5 cm)

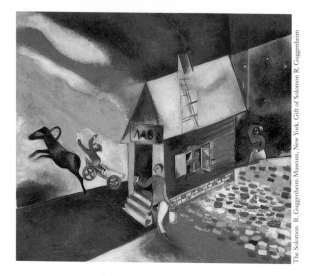

RIGHT
*The Flying
Carriage*
(aka *The Burning
House*). 1913
41 ⁷/₈ x 41 ¹/₄"
(102.2 x 101 cm)

OPPOSITE
*Paris Through
the Window*
1913
53 ¹/₂ x 55 ³/₄"
(135.9 x 141.6 cm)

representation of the rhythmic cycle of rural life as well as an interpretation of the relationship between humans and nature. Especially noteworthy is the artist's depiction of a baby horse, curled up in its mother's womb.

A masterpiece

The next year, Chagall created one of his most magical (and famous) paintings, *Paris Through the Window*. It is a Cubist-inspired—but not Cubist-dominated—view of the Champ-de-Mars, the tranquil back garden of the wondrous Eiffel Tower. However one chooses to describe it, this is a remarkable work of art, with colorful and often startling

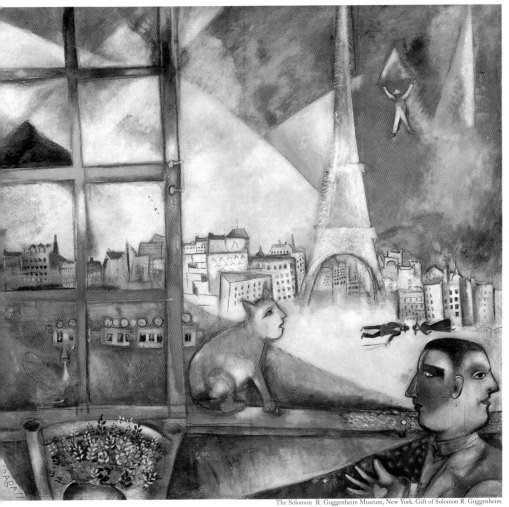

images on every part of the canvas. All of these are open to different interpretations. Is the two-faced man (Chagall?) looking forward to Paris and backward to Vitebsk, or is he simply a man with two homes? (This image has been read as half of Chagall's head being inside him while the other half is outside, in the world.) Does the cat have a human head because the painter wants to show that humans are really—or partially—animals, or is this merely an image that the playful artist enjoyed placing on the canvas? Is there some hidden meaning to the upside-down railroad cars that seem to be moving without tracks, or is this no more than an intriguing pictorial element that pleased Chagall? What about the two figures floating horizontally, head to head, and the parachutist, and that yellow heart on the man's blue hand? Have fun with this joyous, fanciful work, because no matter how you interpret it, the painting can be savored as a rewarding and enriching visual experience on its own.

Striking a different chord, Chagall painted yet another Cubist-inspired work in 1913 entitled *Nude*. The female nude was the subject of a number of his paintings during the period from 1910 to 1914, while he was living in Paris. He was more drawn to the movement of the body and to the relationship between the forms than to the idea of creating a precise rendition of the body itself. Above all, this startling work shows the influence of Picasso and of the latter's revolutionary painting *Les Demoiselles d'Avignon*.

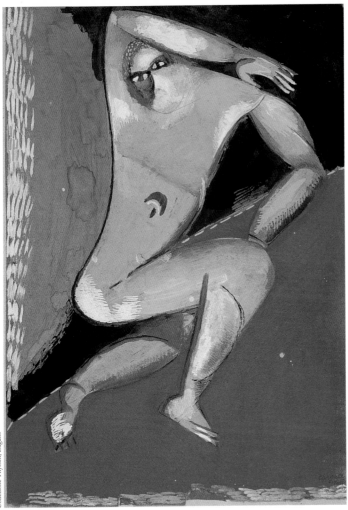

Nude. 1913

Doing it in Deutschland

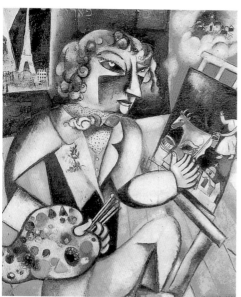

Stedelijk Museum, Amsterdam

Self-Portrait with Seven Fingers
1913–14. 52 ½ x 43 ¾"
(128 x 107 cm)

At last, in 1914, Chagall gained some of the recognition he sought. It came not in France, however, but in Germany. A year earlier, in March 1913, his loyal supporter Apollinaire had introduced him to Herwarth Walden, a German poet, critic, and art dealer who had excellent taste in art and literature. In Berlin, he had founded an influential avant-garde magazine called *Der Sturm (The Storm)*, as well as an art gallery of the same name, in which he had exhibited the works of, among others, Chagall's friend Robert Delaunay. Walden traveled frequently throughout Europe, where he discovered (and later published the graphic work of) some of the most exciting artists of the time.

It was during one such trip that Apollinaire urged Walden to visit Chagall's studio at La Ruche. The dealer was greatly impressed and immediately agreed to exhibit three of the painter's works in a group show scheduled for September 1913, and to show more of Chagall's work the following April.

Most important, Walden offered Chagall his first major one-person show, to be held in June 1914.

This was the opportunity Chagall had so eagerly awaited. He enthusiastically made plans to go to Berlin for the opening and to continue on to Russia for a brief visit—to attend the wedding of one of his sisters and to see his beloved Bella, with whom he had corresponded regularly—before returning to France.

Chagall arrived in the German capital in May 1914 to prepare for his exhibition, which was to open in early June. It was to be huge: 40 oil paintings as well as 160 works on paper, including watercolors and drawings.

The critical and public response was all that the young artist could have hoped for. *Paris Through the Window* was singled out for special praise.

Instead of remaining in Berlin to enjoy his first success, however, Chagall boarded the train for Russia on June 15, the day after the opening.

Stuck in Vitebsk

Chagall returned to Russia a changed man. He had matured in four years, but he had also been transformed by more than the mere passage of time: It was his contact with Paris and the real discovery of his art that had done it. Before he had left Vitebsk, Chagall had thought of the town as a kind of prison from which he had to escape. Now he found it "strange" and "boring" and "unhappy." He felt lost, surrounded by aunts and uncles who kept telling him how big he had grown, and he eagerly looked forward to returning to the energy and excitement of Paris. But, because of events beyond his control, his planned short visit home became a very long one. In August 1914, Germany declared war on Russia, and World War I soon engulfed all of Europe. Travel was impossible, and Chagall was trapped.

During this enforced stay in Vitebsk, the artist embarked on a series of works that proved to be of special value. With his newly developed sense of color and technique, he painted a series of works that he called "documents" of Vitebsk. Believing that he was living during the beginning of the end of an era, of the town as he had known it during his childhood, as well as an end to a way of life, he painted everything and everyone in sight—his parents, his brother, his sisters, the streets and houses and churches of the town as well as its people. They would thus remain recorded forever, not only in Chagall's memory, but also for the whole world to see.

Moving right along

The artist had no home in Vitebsk during his stay there and moved from one rented room to another. Wherever he went, he took his paints and brushes with him and worked energetically, completing almost 60 paintings and drawings within a year.

One of the most memorable works, *Over Vitebsk* (see next page), was painted from the window of a room he had rented from a policeman. The streets that form a crossroads along two sides of the wall are covered with snow. On the right stands the imposing Iltych church, with its pear-shaped dome. What makes the work especially characteristic of Chagall is the presence of an oversized figure—in this case, a large, bearded old man with a sack on his back and a cane in his hand—hovering in the sky over the street and dominating the scene. Who is this old man? The Yiddish expression for a beggar who goes from door to door is "He who walks over the city." The figure might thus be the eternal wanderer, the Jew without a country, tossed into the air to fall down somewhere. Another explanation can be found in Chagall's autobiography where he describes the Biblical prophet Elijah as arriving on earth disguised as a "stooped beggar with a sack on his back and a cane in his hand."

Tracking the crowd

Other works of this period include portraits of members of his family,

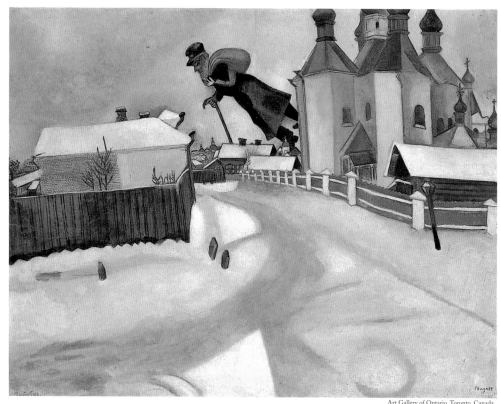

Over Vitebsk. 1914. Oil on
card on canvas. 27 $^7/_8$ x 35 $^1/_2$"
(70.8 x 90.2 cm)

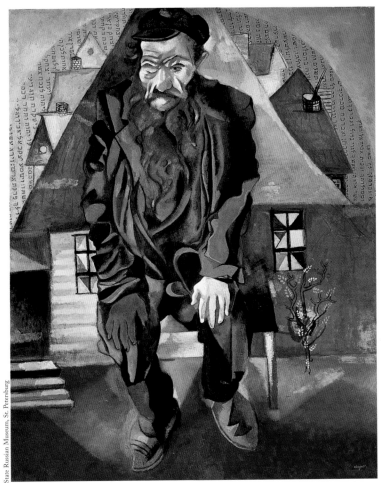

The Red Jew
1915. Oil on
cardboard
40 3/4 x 32 3/4"
(100 x 80.6 cm)

The Praying Jew
(aka *The Rabbi of Vitebsk*)
1914. Oil on cardboard,
mounted on canvas
39 3/8 x 31 7/8"
(96.5 x 78 cm)

as well as a number of striking self-portraits. In addition, he completed portraits of rabbis and old Jews at prayer, as well as studies of children, beggars, and landscapes of Vitebsk and its surroundings, its narrow streets, and its interesting buildings. *The Praying Jew* (aka *The Rabbi of Vitebsk*) dates from this period. Chagall claimed that the model for this work was not really a rabbi but an Orthodox Jew, a sullen, gray-haired old beggar who used to pass by the Chagall home.

If Chagall's art flourished against all odds, so did his romance with Bella Rosenfeld. While apart, they had faithfully written to one another, and when Marc returned to Vitebsk, Bella had just finished her studies in Moscow. Their reunion was a joyous one.

While the painter worked tirelessly on his "documents" of Vitebsk, Bella brought food to his studio at all hours of the day and night, along with love and inspiration. Through her, Chagall learned to paint "portraits" of love that show a rare tenderness and beauty—starry-eyed floating lovers, or upside-down lovers, or lovers lifted off the ground with joy. Thanks to his feelings for Bella, the subject of love—the union of two human beings—became the focus of some of his most magical works.

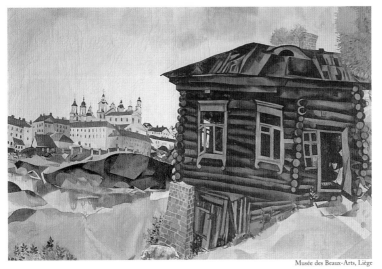

The Blue House
1917. 27 x 39 ½"
(66 x 97 cm)

Here comes the bride

Marc and Bella made plans to marry. The determined Bella had succeeded in getting permission from her reluctant parents, and the date was set for July 25, 1915. The newlyweds spent the first month of their life together in a small village not far from Vitebsk.

In August 1915, the artist asked the governor of the town for permission to return to Paris with his bride, but the necessary exit visa was refused, since the war was still being fought. Instead, Chagall would either have to join the army as a soldier or find work that could excuse him from military duty. Bella's brother, a lawyer in charge of the

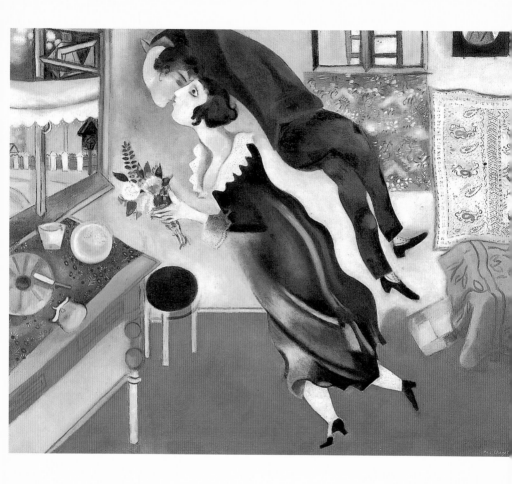

In her memoirs, Bella Chagall wrote of the origins of *The Birthday*. It seems that she visited her fiancé on July 7, 1915, the day of his 28th birthday. She had gone to the outskirts of Vitebsk to pick a bunch of flowers for the occasion and then went home to gather all of her colorful scarves and silk squares, as well as the brightly colored quilt from her bed, to present to the artist. Finally, she went to the kitchen to collect some food for the celebration, after which, dressed in her best dress, she hurried across the river, far from her own home, to the artist's room.

Unaware even that it was his birthday, Marc was shocked to see Bella arrive with her arms full of gifts, but he was both delighted and inspired. As she draped the scarves over his table and walls, and spread the quilt over his bed, he suddenly went through his canvases and placed one on the easel, asking her not to move as he began work on a new painting.

The Birthday remains as a tribute to—and a memory of—their love, and the image of the ecstatic young lovers is one of the most familiar and beloved in all the artist's work.

Bella Chagall, addressing her husband in *First Encounter*, her memoirs, about his technique in painting *The Birthday*, wrote, "You dashed at the canvas with such energy it shook on the easel. You plunged the brushes into the paint so fast that red and blue, black and white, flew through the air. You too were poised on one leg, as if the little room could no longer contain you. You soared to the ceiling."

department of war economy in St. Petersburg, offered him an office job related to the war effort that would exempt him from the life of an ordinary soldier.

Marc and Bella moved to St. Petersburg and rented a small room. Though Chagall was bored with his job, this assignment allowed him to stay out of a soldier's uniform and to come home each night to his beloved Bella. It also made it possible for him to paint throughout the war years and to show his work to some of the richest and most influential collectors in Russia, many of whom bought his paintings. The number of serious art collectors, especially in the Jewish community, was growing, and Chagall did his best to interest them in his work. Through them and through exhibitions in Moscow and in St. Petersburg, his reputation as one of the most prominent artists in Russia spread.

A baby arrives

As Chagall's fame grew and articles about his work were published, so did the scope and nature of his art. On May 18, 1916, a daughter, **Ida Chagall** (1916–1994), was born, and the beautiful child became the subject of some of the artist's most gentle portraits. He spent much of his free time in the countryside, and scenes of country life became a theme of his paintings. But the horrors of war, with its tired, anguished soldiers, were also depicted in works created that year.

Such was the power of his love for Bella that, in 1917, Chagall celebrated it in the joyful *Double Portrait with Wine Glass* (see page 62). In this work, the painter shows his bride holding him aloft while he raises a toast to their happiness. Above the starry-eyed couple, an angel (is it Ida, their infant daughter?) offers a blessing.

Upheaval at home

At the end of 1917, the Russian government signed an armistice agreement with Germany, leading to Russia's withdrawal from the war. At any other time, such an agreement would have caused Chagall to seize the chance to return to France, but an event of even greater significance to him—the **Russian Revolution**—drove all such thoughts from his mind. Earlier in the year, the Russian people had risen up against **Czar Nicholas II** (1868–1918), Emperor of Russia, and had forced him to abdicate. On November 7, the Bolshevik workers, led by **Vladimir Ilyich Lenin** (1870–1924), completed the Revolution by seizing power and establishing a "dictatorship" of the proletariat (i.e., the common people), a Communist state.

As a consequence of this revolution, the rights of full citizenship were restored to all of Russia's Jews. They would no longer be persecuted and forced to live under the harsh conditions that had been imposed upon them during the reign of the czars. Jews would be free to live and travel wherever they wanted, and work at whatever jobs they chose.

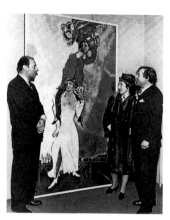

RIGHT
*Double Portrait with Wine
Glass*. 1917. 92 ¹/₂ x 54"
(235 x 137 cm)

This was no time for Chagall to leave the country of his birth. Instead, as a respected, successful artist, and as a Jew, he wanted to take advantage of this freedom and hoped to play a leading role in the artistic life of the new Russia. It was a period of enormous excitement. At Bella's urging, however, the painter took his wife and daughter back to Vitebsk, away from the chaos and tumult of postrevolutionary Petrograd, as St. Petersburg was then called. If Chagall was to play an official role in the cultural revolution that was sweeping through Russia, he would do so from Vitebsk, where life was more peaceful.

Art for the people

An opportunity to play such a role presented itself within a few months. Shortly after his return to Vitebsk, Chagall worked out a plan to create a new art school there and sent it to **Anatole Lunacharsky** (1875–1933), the Commissar of Education and Culture in Moscow. Lunacharsky was impressed, and, on the basis of the plan, he appointed Chagall Commissar for the Fine Arts in Vitebsk. The artist's task—to turn his town into a flourishing art center—was a challenging one. Though his primary responsibility was to establish and become director of the new school of fine arts, he was also empowered to organize museums, exhibitions, lectures on art, and all other artistic ventures within the city and region of Vitebsk. He plunged into his work with his usual enthusiasm and energy. Nothing was too difficult for him. Even before officially taking office, he organized a large exhibition of

paintings by Vitebsk artists. Included were works of his former teacher, Yehuda Pen, and his friend Victor Mekler, as well as five of his own paintings, among them the joyful *Double Portrait with Wine Glass.*

OPPOSITE
Rest. 1975

It was an impressive exhibition. But an even larger chance to show what the artists of Vitebsk could do came in November 1918, on the first anniversary of the Revolution. It was to be a day of celebration, marked by parades and festivities throughout Russia. To demonstrate the vitality of Vitebsk, Chagall brought together all of the town's artisans and craftspeople. The center of the town was joyously decorated: Shops and trolleys were newly painted in red, purple, yellow, and green; colorful flags, banners, and posters lined the streets, and Chagall's own designs were everywhere in evidence. The people of Vitebsk were more invigorated and excited than they had ever been, and the man who had organized this triumphant ceremony took special pride in the smiling faces of the workers as they marched through the town.

Official reaction, however, was less enthusiastic, and Chagall was angrily criticized by leaders of the newly formed Communist party. Why was the horse green? Why was the cow flying through the air? What did all this have to do with the Revolution or with Lenin? Some critics solemnly noted how many sets of underwear could have been made with the material they felt had been wasted on the flags and banners.

Though disappointed by this official reaction, Chagall was not surprised.

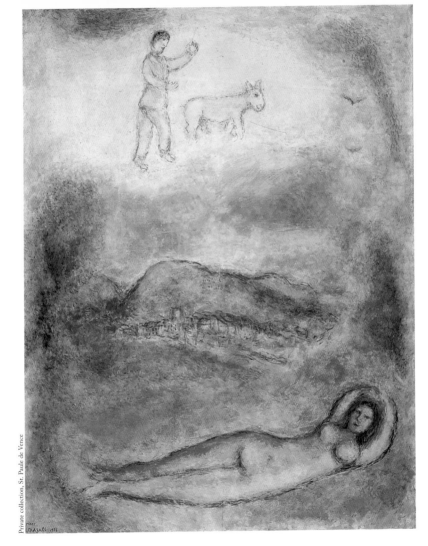

He had known from the beginning that he could no more rigidly follow any political doctrine than he could completely follow any artistic doctrine. He was an artist, a free man, and whatever the party leaders said, he was determined to work toward his goal of establishing Vitebsk as an important center of the arts.

An exciting new project

Chagall managed to raise the money necessary to realize his dream. By 1919, both a new museum and an academy of the arts were ready to open. Chagall was more interested in the school, since that was where he could turn the young people of Vitebsk into creative forces for the years to come.

The Academy expanded rapidly under Chagall's energetic leadership and with the help of teachers he had recruited from all over Russia. Before long, the school had 600 students. Chagall himself was loved and respected by these young people. Not everyone, however, was enthusiastic about Chagall's efforts. Outside the Academy, he was attacked by conservatives who felt that students should be taught to paint works that realistically depicted the life of the country and its people and not the creatures of imagination that peopled Chagall's work. Inside the Academy, there was an even more serious threat from **Kasimir Malevich** (1878–1935), one of Russia's best-known painters. Malevich, who had developed the experimental art movement known

as *Suprematism*, based on abstract geometric forms, had been invited by Chagall to teach at the Academy in late 1919. Malevich's art and ideas were completely different from those of Chagall. He disapproved of Chagall's "storytelling" through his art and his use of vivid colors. Gradually, the school became divided into two camps, and the rivalry between the two artists became increasingly bitter. It reached a climax when, following a trip to Moscow, where Chagall was soliciting funds for the Academy, he returned to Vitebsk to find that the sign above the door to the school had been changed from Free Academy to Suprematist Academy.

Enraged by this betrayal on the part of colleagues he himself had brought to the school, he submitted his resignation at once. Many students and faculty members begged him to remain, but his mind was made up. Unappreciated at home, he was determined to leave both the Academy and Vitebsk. He was bitter, and never again returned to the city of his childhood.

Sound Byte:

"I won't be surprised if my town obliterates all traces of me and forgets the man who, laying aside his own paint brushes, worried, suffered, and took the trouble to implant Art there."

—MARC CHAGALL, on his anger over being betrayed at the Free Academy

Off to Moscow

In May 1920, Chagall settled in Moscow. Though he was known as an artist and cultural leader throughout Russia, he had earned little money. Because of this, he and Bella and Ida were forced to live in one small, damp room. There were terrible food shortages, and it was sometimes impossible to get milk for the child. But the move to Moscow had achieved one positive result: It offered Chagall the opportunity to fulfill a dream to work in the theater. Years before, in St. Petersburg, he had been asked to submit ideas for a theatrical production, but these had been rejected as too radical. Now, in Moscow, he met **Alexis Granovsky**, a man who had the vision to go along with these ideas.

Granovsky had recently embarked on a new venture. In an attempt to bring vitality and freshness to Jewish culture, he had founded the State Jewish Theater, which, when Chagall met him, had just moved to new quarters in Moscow. For the occasion, the painter was asked not only to design the sets and costumes for the company's new production, but also to execute a mural for the theater's auditorium. Given a free hand by Granovsky, Chagall took over every aspect of the production. He created the sets, the costumes, the makeup, and even choreographed the movements of the actors. It was exhausting but exhilarating, and its enormous success justified the work the artist had put into it.

In spite of this artistic triumph, Chagall continued to earn little money.

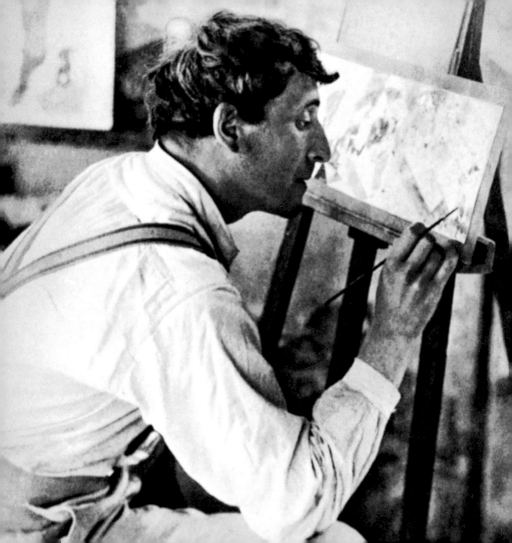

Granovsky was unable to pay him for his work in the theater, and buyers for his paintings were hard to find. He was forced to accept a position in a war orphans' colony near Moscow. Teaching these sad young people how to paint was a satisfying and often moving experience, but it could not become his life's work. He was a painter, and he had to paint, yet there seemed to be no place for him in Russia. In 1921, he began writing his autobiography, *My Life*, and completed it in 1922. He dedicated the book "to my parents, to my wife, to my native town."

Sound Byte:
> *"They don't understand me. I am a stranger to them."*
> —MARC CHAGALL, writing about his countrymen, the Russians

Soon, however, he learned that there was a place for him outside Russia. In 1922, a letter arrived from his friend **Ludwig Rubiner** in Berlin: "Are you alive? There is a rumor that you have been killed in the war. Do you realize you are famous here? Your pictures…[are] selling for high prices." The letter was decisive. Discouraged by his attempts to gain recognition in Russia, he would return to Western Europe to further his career as an artist.

On to Berlin

In the summer of 1922, Chagall left Russia. His first stop was Berlin, where he confirmed what his friend had written: He was indeed famous in the German capital. Throughout the war and after it, Herwarth Walden had continued to exhibit Chagall's work, and many of his paintings had been sold to private collectors. There had been a number of articles about him, and his fame had spread, as had his influence on many young artists. But there were disappointments, too. For one, Walden was either unwilling or unable to tell him where his paintings were, both the sold and the unsold ones. For another, the money that he had earned through the sale of his paintings was far less than he had expected. Walden felt Chagall should be content with glory and fame, and not covet the money.

Chagall remained in Berlin for a year, where he was able to make friends among the important critics and artists working in the German capital. Of these, the most important to his career was **Paul Cassirer** (1871–1926), a distinguished art dealer and publisher. Cassirer had learned that, while in Moscow, Chagall had completed an autobiography. Cassirer read the text and proposed

Paul Cassirer

*House in
Pestkowatik*
1921–22
Drypoint
with etching

The Jewish Museum
New York

to publish it—together with 20 **etchings** he asked the artist to create to accompany the autobiography. Chagall accepted the commission with enthusiasm. The technique of etching (i.e., drawing with a steel instrument on a wax-coated copper plate that is then etched with an acid in preparation for printing) was new to him, but he mastered it in a remarkably short time. Even though Cassirer never published the text of the autobiography, he did publish a portfolio of 20 of Chagall's etchings in 1923, a poignant record of his childhood and early years in his native land. In *House in Pestkowatik*, a horse and cart speed so quickly past Chagall's childhood home that they seem to be flying. In

Beside My Mother's Tombstone
1921–22
Etching

75/110

Manilov, illustration for
Dead Souls of Gogol
1923–27. Etching and drypoint
11 ¼ x 8 ⅝" (28.5 x 22 cm)

Beside My Mother's Tombstone, the artist kneels beside his mother's grave, a moving representation of Chagall's profound love for his mother.

Paris beckons…again

Much as he had profited from his stay in Berlin, Chagall remained eager to reach his final destination—Paris. While in the German capital, he had learned that he was as famous in Paris as he was in Berlin. Furthermore, during the summer of 1922, he was informed that the greatest of all French modern art dealers, **Ambroise Vollard** (1865–1939), had seen his paintings and was anxious to discuss a major new project with him. On September 1, 1923, Chagall, this time with Bella and their seven-year-old daughter, Ida, returned to his artistic birthplace, Paris. He felt he had come home.

It was the beginning of a period of artistic and personal success that came to an end

only in 1941, with the outbreak of World War II. Shortly after his arrival in 1923, Chagall paid a call on Vollard, who had been kind to a great number of artists. The meeting was a success. In the course of it, the legendary dealer (and publisher) asked Chagall to illustrate *Dead Souls*, the great 19th-century Russian novel by Nikolai Gogol. Vollard also agreed to pay the artist whatever he needed to complete this new set of etchings. Chagall was overjoyed. He loved Gogol's book, and Vollard's generous offer freed him from all financial worries.

Vollard's decision proved to be an inspired one. Because of his own background, Chagall was uniquely qualified to bring to life through his art Gogol's satire of Russian peasant life. In the 107 illustrations that he etched between 1923 and 1927, the artist lovingly conveyed the warmth and poetry of his homeland and depicted its often larger-than-life people. It was the first of several successful collaborations between Vollard and Chagall.

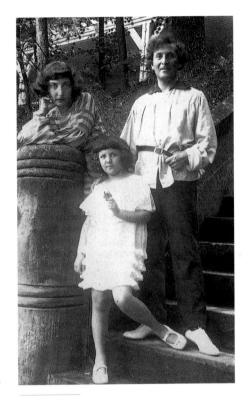

Bella, Ida, and Chagall
1923

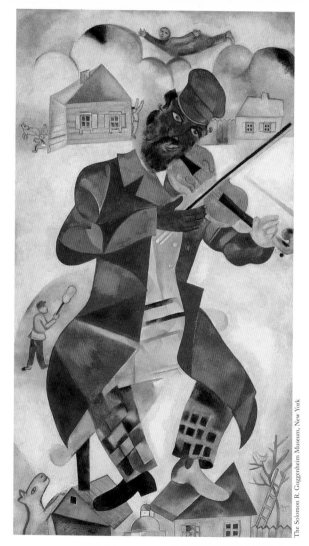

*The Green
Violinist*
1923–24
78 x 42 ³/₄"
(198 x 108.6 cm)

Famous fiddlers

While working on the *Dead Souls* etchings, Chagall also found time to paint. He was inspired by memories of the past and he enjoyed making portraits of violinists, who played an important role in the life of small Russian villages, where there were no orchestras or concert halls. *The Green Violinist* is probably Chagall's most popular version of this theme. (There is no connection between Chagall and the Broadway musical *Fiddler on the Roof*, which is based on a story by Sholom Aleichem.) The painting is dominated by a huge fiddler, playing his orange and yellow instrument while one foot rests on a brown rooftop and the other on a gray one. *He is a fiddler on the roofs!* One of his shoes is black and the other is tan. His long coat and his cap are violet, while his face is a greenish blue. He's in a sitting position, but it's impossible to tell what he's sitting on, if anything. Above him are a few houses, and above them a violet-clad man floats among the clouds. The fiddler's face is crooked—his mouth goes off to one side, his nose to another. On the bottom left, an animal looks wistfully at the fiddler; on the right is a tree with a ladder propped up against it—Chagall said that the ladder referred both to Jacob's ladder and to his own desire to be high up on a ladder as a child—and a bird on one of its bare branches. Everything seems to be moving, and the rhythm is unmistakable. The work is not only signed "Marc Chagall" but on one of the violinist's trouser cuffs, the words "Oh! Daddy" are inscribed, in Hebrew.

This lively painting is a recreation of one of the many important works that the artist had lost in Germany or Paris during the war (or that he had had to leave behind in Russia). These versions, which date from his return to Paris in 1923, were, for the most part, created from memory or from photographs. The earlier version of this particular piece is one of the works the artist painted in 1920 for the auditorium of the State Jewish Theater in Moscow. Chagall was also moved by the varied French countryside that had inspired so many great painters. Whenever they could, he and his family traveled—from the rugged French Alps to the rolling, colorful hills of the South—discovering and growing to love their new homeland. Never before these travels had he painted nature so poetically. Rural scenes, barnyard animals, blue seas, and, above all, color-splashed flowers became prominent in many of his paintings at this time.

Sound Byte:
"I have always thought of clowns, acrobats, and actors as being tragically human beings, who for me resemble the figures in certain religious paintings."
—MARC CHAGALL

Fables and more

This newly developed knowledge and understanding of nature—of plants and animals—was undoubtedly one of the factors that led to

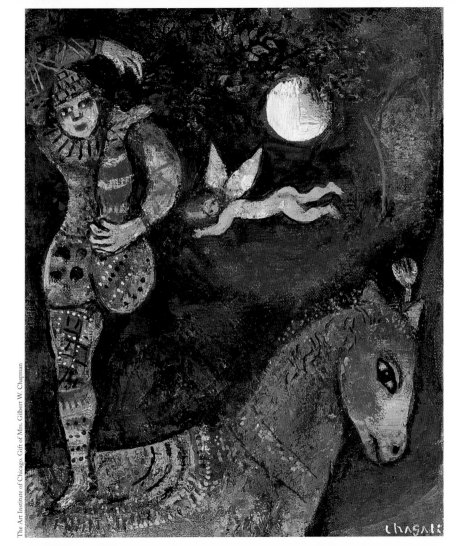

chagall

The Joker and the Fish
1927–28
Gouache for
the *Fables* of
La Fontaine

Vollard's next idea: that Chagall illustrate a 17th-century French classic, the *Fables* of La Fontaine. Chagall and La Fontaine, one of the most beloved of all French writers, seemed a perfect combination to the artist and to Vollard, but much of the French public was horrified. These affectionate, charming tales, in which talking animals—crows, ants, mice, and others—take on human characteristics, were taught in schools throughout France as examples of the clarity and beauty of the French language and spirit. How, these critics argued, could a Russian Jew capture this uniquely French quality in his illustrations? Vollard paid no attention to these objections. The indignant critics had ignored the fact that the *Fables* had been adapted from early folk tales (such as those of Aesop), or from more modern ones, many of which originated in the East. They were not French, but universal.

As a bit of a detour, Chagall painted *The Rooster* (see next page) in 1929, a marvelous canvas in which rich reds and yellows distinguish a tender portrayal of a female harlequin, clad in red tights, who lovingly embraces a splendid smiling rooster. The two human lovers in the little rowboat in the background echo this theme of love. Chagall's 100 etchings for the *Fables*, executed between 1927 and 1930, were a masterful achievement, but even before finishing them, he and Vollard agreed on the next work to be illustrated: the Bible.

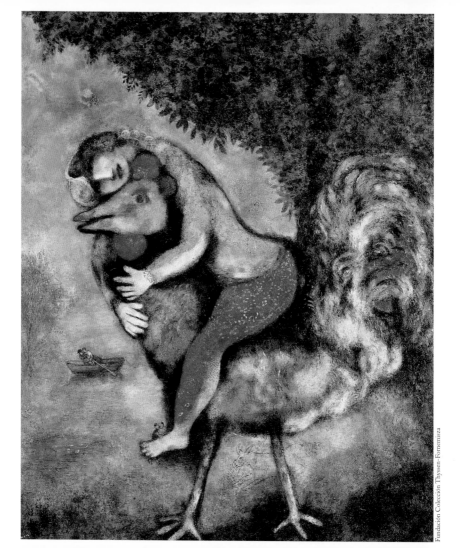

The Holy Land

The artist approached this awesome task with reverence and enthusiasm. The Bible and its characters had been an unforgettable part of his childhood in Vitebsk. Yet, to do his job well, he felt it necessary to go to the land of the Bible—to Palestine—to feel at first hand the spirit and poetry of the Bible. In February 1931, he arrived in Palestine (which would become the State of Israel in 1948) and remained there for nearly three months. It was an unforgettable experience. Totally captivated by the Holy Land, he felt the past and present come together as one, and rediscovered the faces of his childhood. The latter, coupled with the dazzling light that shines upon the Holy Land, found their way into his paintings. When the artist returned to Paris, he began work on the Biblical etchings, an undertaking that would last many years (they were not completed until 1956). These 105 illustrations are considered by some to be among the great inspirational works of art of all time.

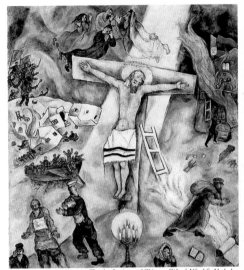

The Art Institute of Chicago. Gift of Alfred S. Alschuler

ABOVE
White Crucifixion
1938. 63 x 57"
(154.3 x 139.7 cm)

OPPOSITE
The Rooster
1929. 33 x 26 ½"
(81 x 65 cm)

83

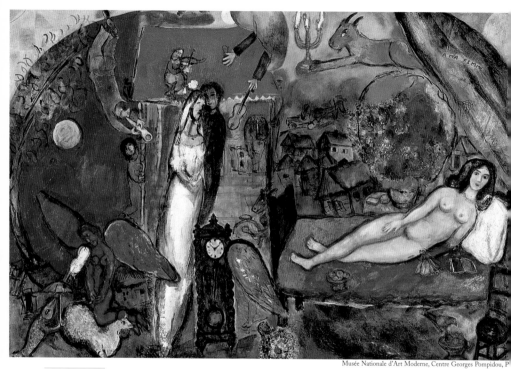

To My Wife
1933–34. 43 $^3/_4$ x 73"
(107 x 178.8 cm)

New horizons

During the 1930s, the Chagalls traveled a lot outside of France. In 1932, a visit to Holland enabled the artist to study the paintings and etchings of the Dutch master **Rembrandt van Rijn** (1606–1669). On a trip to Spain, he was deeply moved by the works of the Spanish masters **Diego Velázquez** (1599–1660) and **Francisco Goya** (1746–1828), and in 1937, on a visit to Italy, Chagall had an opportunity to study the works of the great Italian artists—the painters **Giovanni Bellini** (c. 1430–1516) and **Titian** (1477–1576), and the sculptor **Donatello** (c. 1386–1466), among others—in the museums of Florence. Contact with the great masterpieces of the past strengthened the painter's art and added a seriousness to it.

Hatred by Hitler

However, a 1935 trip to Poland, where he attended the inauguration of a Jewish cultural center in Vilna, had special meaning for him. There, only 200 miles from Vitebsk, he once again came in contact with the life of Eastern European Jews. He was profoundly saddened by what he saw: These Jews and their way of life were

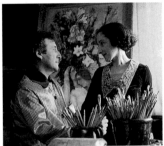

Photo: Lipnitzki-Viollet, Paris

Private collection, St. Paul de Vence

TOP
Chagall and Bella, August 1934

BOTTOM
The Painter. 1976
26 ¹/₂ x 22" (65 x 54 cm)

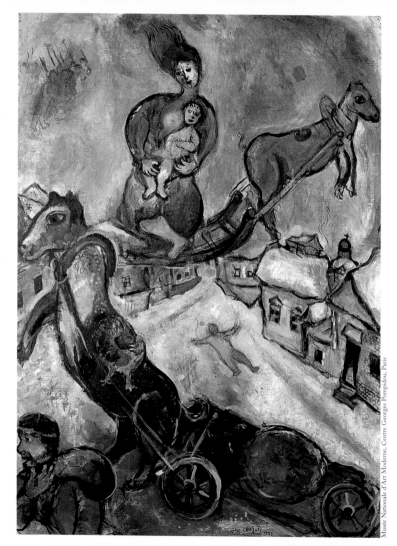

RIGHT
The War
1943
42 ³/₄ x 31"
(105 x 76 cm)

OPPOSITE TOP
Vase of Flowers
c. 1938–41

OPPOSITE
BOTTOM
*A Midsummer
Night's Dream*
1939
46 ¹/₈ x 34 ⁷/₈"
(113 x 85.4 cm)

again threatened, this time by **a wave of anti-Semitism that was sweeping Europe**. This experience introduced an element of apprehension and tragedy to his work. Burning villages and fleeing peasants became his subjects, evoked in blacks and grays instead of the bright colors for which he was known. In 1937, by order of the Nazi regime, all of Chagall's works were removed from German museums. (In 1933, a number of Chagall's paintings had been publicly burned by the Nazis at the gallery of his dealers, Mannheim Kunsthalle.)

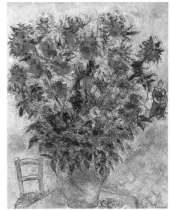

Private collection, St. Paul de Vence

His fears for the future proved to be well founded. German troops invaded Poland on September 1, 1939. It was the beginning of World War II. Two days later, England and France declared war on Germany. An all-out effort had to be made to stop the aggression of Hitler's Germany, which threatened to overrun Europe. Danger and gloom were in the air, and the wrenching sadness of this period is captured in *A Midsummer Night's Dream*, painted in 1939. This touching portrait shows a dejected, melancholy Minotaur, dressed in mourning clothes, caressing and clinging to his beautiful bride.

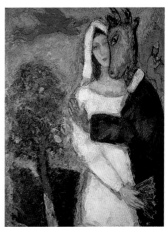

Musée de Peinture et de Sculpture, Grenoble

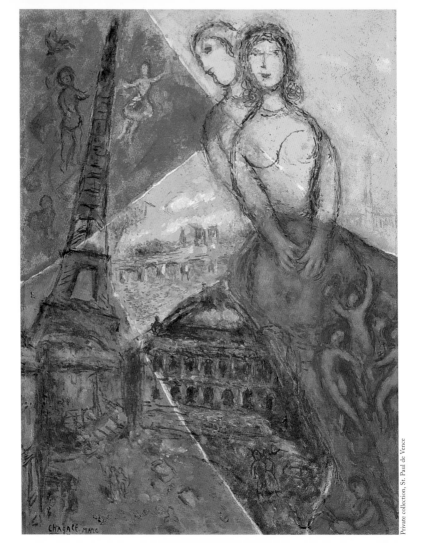

Moving south

Chagall had lived through war and revolution, and he knew the destruction they wrought. In August 1939, he and his family had gathered up his work and moved to Saint-Dyé-sur-Loire, a small village not far from Paris, where he felt there was less chance of danger. But by the spring of 1940, the situation had worsened. Denmark, Norway, Belgium, the Netherlands, and Luxembourg had been invaded by the German armies. It was clear that the battlefield would move to France, and that the area near Chagall's home would most probably be a major line of defense for the French forces. It was time to move once again, this time to the South of France, where they found a home in the ancient village of Gordes, near Avignon, in the region of Provence.

France collapses

On June 22, 1940, little more than a month after they had bought their home, France surrendered to the German army. It was a dark period for the free world and a dangerous one for all Jews, who had become the prime targets of Hitler's madness. In spite of the risk to his life and to that of his family, Chagall remained in Gordes for almost a year, hoping that France would drive out the enemy. He dreaded the thought of once again leaving the country in which he felt so much at home, and stubbornly refused all efforts to convince him to emigrate. A tempting offer arrived one day in the form of an invitation from

OPPOSITE
Memories of Paris
1976

New York's Museum of Modern Art, brought to him by **Varian Fry**, the American director of the Emergency Relief Committee, an organization whose purpose it was to bring important European intellectuals and artists to safety in America.

Chagall was bewildered by Fry's argument that his life was actually threatened as long as he remained in France. Furthermore, the idea of crossing the ocean to go to America was frightening. It was too far away and Chagall knew nothing about the country.

Sound Byte:

"Are there trees and cows in America, too?"

—MARC CHAGALL, in a letter to Varian Fry

At first, Chagall refused Fry's generous offer. In April 1941, however, when France adopted severe anti-Semitic laws and the Nazi-dominated French government began rounding up Jews and sending them to prison, the artist changed his mind. It was a difficult and painful decision, but he realized he had no choice.

Safety in America

On May 7, 1941, Bella, Ida, and Marc Chagall, weary and frightened, left France, crossing the border into Spain. From there they traveled to

Lisbon, Portugal, where they waited until they found space on a cargo ship that would take them to America. The crossing lasted 43 days.

The Chagalls arrived in New York on June 23, 1941, in search of a new home, one in which they might live until the war ended. The Germans had invaded their first home, Russia, only the day before. They were refugees, among the many thousands who had been driven from their countries by the threat of Nazi persecution and who had found asylum in the United States.

Chagall was among the more fortunate of these uprooted people. His work was well known in America from reproductions in art magazines and was part of several important museum and private collections. And he had a dealer and friend, **Pierre Matisse** (1900–1989), son of the great French painter Henri Matisse, who was willing to show his work in his New York gallery and help spread his fame. He had managed, through complicated efforts by his daughter, Ida, to send ahead all of his paintings, drawings, and studies, packed in trunks and weighing 3,500 pounds. This enabled him to begin painting at once and to complete canvases he had been working on for years.

In spite of these advantages, Chagall found life in New York difficult. He was overwhelmed by the immensity of the great city, its towering skyscrapers, and its dizzying pace. In the seven years during which he lived in and around the city, he never came to feel at home there. He knew little English, and because he refused to learn it—preferring to

speak French, Yiddish, or Russian—he lived mainly in a world of displaced Europeans.

To the ballet

It was through one of these, the great Russian choreographer **Leonid Massine** (1896–1979), that Chagall received his first important job in America. The Ballet Theater of New York invited him to design the scenery and costumes for a new work conceived and choreographed by Massine. The story of the ballet, *Aleko*, was based on a 19th-century poem, *The Gypsies*, by **Alexander Pushkin** (1799–1837), the great Russian poet. The music was by **Peter Ilyich Tchaikovsky** (1840–1893), the great Russian composer. It was the ideal assignment for two Russians working in America; it enabled them to recreate their homeland from memory among the skyscrapers of New York.

Because of an invitation by the Mexican government, the first performance of the ballet was to be given not in New York but in Mexico City in September 1942. To prepare for it, the Chagalls and Massine arrived in Mexico during August. As he had done in the past, the painter involved himself in every aspect of the production. No detail, no minor prop escaped his attention. Bella again was of great help, supervising the making of the costumes, based on Chagall's sketches, while the artist himself painted the four huge backdrops he had conceived.

At the ballet's opening, the Mexican audience was enchanted by the production. Music, poetry, movement, and color had been combined into a glowing whole. Time and again, Chagall was called on stage to acknowledge the cheers. It was in every way a triumph, and this triumph was repeated at its New York premiere one month later.

After his return to New York, Chagall resumed his painting. Many of his canvases showed the influence of the strong, vivid Mexican colors and light. Other works were more somber and troubled, reflecting his concern for the suffering of the land of his birth. In his warm and richly colored 1943 painting *The Juggler*, Chagall combines warm memories of his years in his hometown with his love for animals and enthusiasm for the circus.

French Newspaper article about Chagall in New York, showing photograph of Chagall and his daughter, Ida. 1943

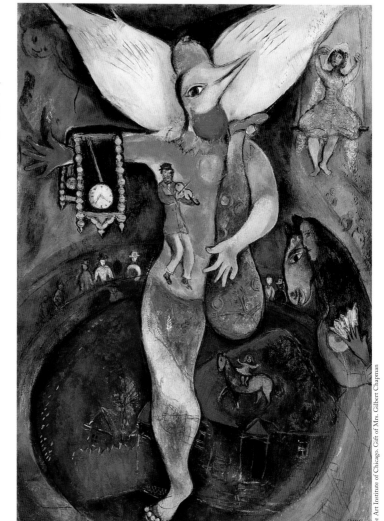

The Juggler
1943
44 ¹/₂ x 32 ¹/₄"
(109 x 79 cm)

Death of a soul mate

Even though their official home during these years in America was New York, the Chagalls spent much time outside the city. For the summer of 1944, they rented a home at Cranberry Lake, in the Adirondack Mountains. There, on August 25, they learned that Paris had been liberated from German rule. They were elated; the war was not yet won, but they felt certain that the end was near and that they could soon return to their home in France. In the midst of their elation, however, personal tragedy struck. Only a week later, Bella took ill, and what seemed to the doctors in the Cranberry Lake hospital a minor virus infection proved to be a deadly infection that took her life on September 2, 1944.

It was a shattering loss for Chagall. For nearly 30 years Bella had been his companion and his inspiration, as well as his most perceptive critic. Chagall was unable to work for nine months. He spent his time in his studio, his

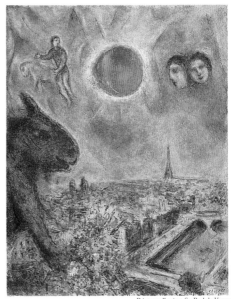

Private collection, St. Paul de Vence

Sun over Paris
1975

canvases turned to the wall. When, after these months of solitude and grief, he began to paint again, his work was often melancholy and subdued, reflecting the enormous loss he had suffered.

Sound Byte:
"A loud clap of thunder and a burst of rain broke out at six o'clock in the evening on the 2nd of September, 1944, when Bella left this world. Everything went dark before my eyes."
—MARC CHAGALL, on the death of his wife, Bella

Another big ballet

A chance to recover from his depression and loneliness presented itself in 1945 when the Ballet Theater of New York again commissioned Chagall to design the scenery and costumes for a ballet. This time it was *The Firebird*, based on an old Russian folktale and danced to the music of another Russian, the contemporary composer **Igor Stravinsky** (1882–1971). As always, Chagall gave himself completely to the job. His daughter, Ida, now 28, was at his side, supervising the making of more than 80 costumes as Bella had once done. The production, which opened in New York in October 1945, was another great success.

Back to France

The new life the artist sought would be lived in France. The war in Europe ended on May 7, 1945, when Germany surrendered. In the spring of 1946, following a large exhibition of his work at New York's Museum of Modern Art and at the Art Institute of Chicago, Chagall returned to Paris for a visit. The following year, he visited the French capital again, this time for an exhibition of his work at the Musée National d'Art Moderne. In 1948, he returned to France for good, grateful for all that America had done for him but happy to be home.

By this time, his position as one of the most significant painters of his era was secure. Important exhibitions of his works were held throughout Europe—in London, Amsterdam, Zurich, Bern, and Venice. As always, he continued to work hard, wherever he went. In 1949, he moved to the South of France, to the delightful town of Saint-Jean-Cap-Ferrat. The following year, he bought a home, Les Collines (The Hills), in St. Paul deVence, France, a small town above the Riviera, where he worked among the fruits, flowers, and scents of the Mediterranean countryside.

Vava voom!

On July 12, 1952, a few days after his 65th birthday, Chagall married Valentine ("Vava") Brodsky, a Russian-born woman of great charm and

Chagall with Pablo Picasso
c. 1952

Chagall and Valentine (Vava) Brodsky
June 1962

intelligence, with whom he spent the rest of his life. They had met only six months earlier, through the painter's daughter.

His life had been an extraordinarily rich one, but rather than merely contemplate his past achievements, Chagall continued to seek new artistic challenges. For the remainder of his very long life, he continued to paint with vigor, expressing on canvas his love for the world of nature and animals, for music and for dance, and for the circus. His themes remained the same—floating, embracing lovers, flying cows and horses, sparkling bouquets of flowers—but his canvases were larger and his colors more dazzling than ever. He returned to biblical subjects as well and painted a series of huge canvases. Witness his brilliant use of colors in *Le Champ-de-Mars*, where he evokes one of the most familiar sites of Paris, the location of the Eiffel Tower (seen at the upper right). Symbols and memories of his distant past are once again combined with those of his recent years.

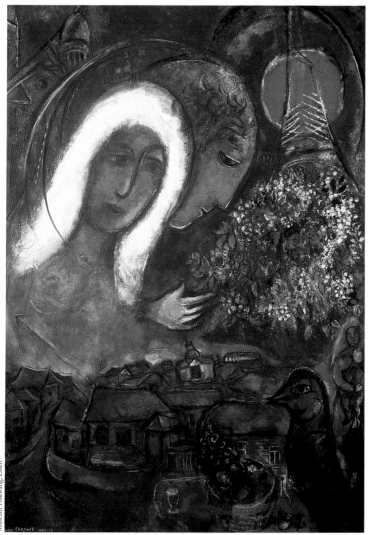

Le Champ-de-Mars
1954–55. 61 x 43"
(149.5 x 105 cm)

Windows in Israel

But Chagall, a man of enormous energy, was not content to spend the rest of his life painting on canvas. He worked in the theater again, designing sets and costumes for a ballet in Paris in 1958, and two years later he created 12 stained-glass windows for a small synagogue that is part of the Hadassah-Hebrew University Medical Center in Jerusalem. The windows are considered by many to be among the finest stained glass of the 20th century. Unable to portray the human face in a Jewish house of worship, Chagall placed in his windows the figures of animals, birds, winged horses, and flowers, together with religious symbols such as the Star of David, candlesticks, and the Tablets of the Law.

When Chagall attended the unveiling of his windows in 1962, he

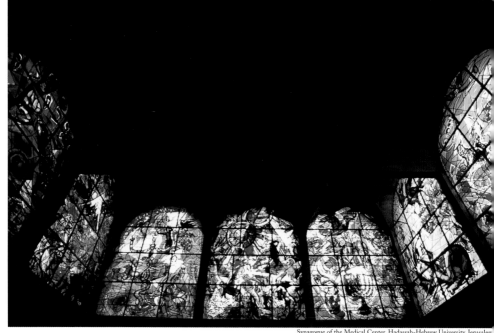

Synagogue of the Medical Center, Hadassah-Hebrew University, Jerusalem

Detail from *The Twelve
Tribes of Israel*
1960–63
Stained-glass windows

received an offer from the Speaker of the Knesset (the Israeli parliament) to decorate the state reception hall in the new parliament building. The project thrilled Chagall, who decided in the summer of 1963 to create tapestries instead of stained-glass windows, since the natural sunlight in the building was so brilliant. His subject was the History of the Jewish People, from their return to their homeland, Zion, through the creation of the State of Israel. Chagall decided to capture the story in three tapestries and on November 30, 1963, he delivered his first *cartoon* (i.e., a preparatory gouache that served as a model for the tapestry weavers) to the Paris-based tapestry manufacturers, the world-famous Manufacture Nationale des Gobelins, founded by Louis XIV in the 17th century.

At the Opera

In 1964, he created a huge circular painting that decorates the ceiling of the great Paris Opera House. Chagall conceived this magnificent work as a mirror to reflect "in a bouquet of dreams the creations of the performers and composers." It is like a flower with five petals. Each has a dominant color—blue, green, white, red, and yellow—and each contains familiar symbols of the world of ballet and opera.

Tapestries and murals

The same year, he met **Yvette Cauquil-Prince**, one of the world's great

master artisans of tapestries, and designed a colorful tapestry that she would manufacture a year later, the first of numerous tapestries on which they would collaborate. After a trip to Israel in the summer of 1965, Chagall finished the cartoons for the second and third tapestries for the Knesset. (The weaving of the triptych began in February 1965 and would be completed by early 1968.)

In 1966, he painted two enormous murals for the foyer of New York's Metropolitan Opera House at Lincoln Center, *The Sources of Music* and *The Triumph of Music*. They are joyful demonstrations of his lifelong passion for music and, at the same time, they recall the symbols and sites of his life. The spectator enjoys not only the birds and flowers and lovers and winged animals, but also views of the city he once called home: the New York skyline, the George Washington Bridge, and so on. In 1967, he designed sets and costumes for an opera, Mozart's *The Magic Flute*, at the Metropolitan Opera in New York.

ABOVE
Tapestry from the windows at the Hadassah-Hebrew University Medical Center, Jerusalem. c. 1966

OPPOSITE
The ceiling of the Paris Opera. 1964
Oil on canvas mounted on ceiling
Approx. 90' sq. (320 m sq.)

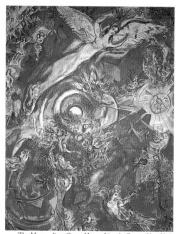

The Metropolitan Opera House, Lincoln Center, New York

ABOVE
The Triumph of Music
1966. Mural painting
oil on canvas
35.75 x 29.25'
(Approx. 11 x 9 m)

RIGHT
The Sources of Music
1966. Mural painting
oil on canvas
35.75 x 29.25'
(Approx. 11 x 9 m)

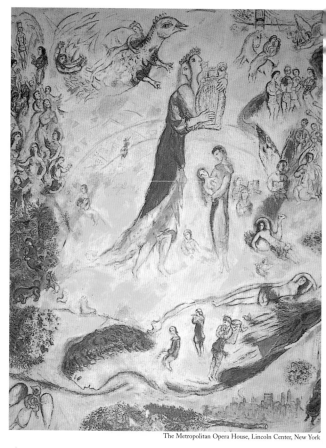

The Metropolitan Opera House, Lincoln Center, New York

Late in life, Chagall's creative curiosity drove him to seek new means of expression for his art. He began to execute sculptures in clay and in stone; he created ceramics and mosaics, and collaborated on more tapestries. Even more remarkable, at the age of 70 he furthered his mastery of the intricate and difficult art of stained glass, which was especially suited to his brilliant and translucent colors. His windows, created over a period of 20 years, enrich many buildings and churches in France, Switzerland, Germany, England, the United States, and Israel. On July 7, 1967, Chagall celebrated his 80th birthday. He had no time for formal celebration. At an age when most people feel their work has been completed, the artist was looking toward the future.

Photo: Darius Cauquil

Marc Chagall. 1966

Sound Byte:
"I work in whatever medium likes me."
—MARC CHAGALL

The next decade was marked by more creative challenges and by further honors. In 1969, at the Grand Palais in Paris, Chagall helped organize a huge retrospective exhibition of

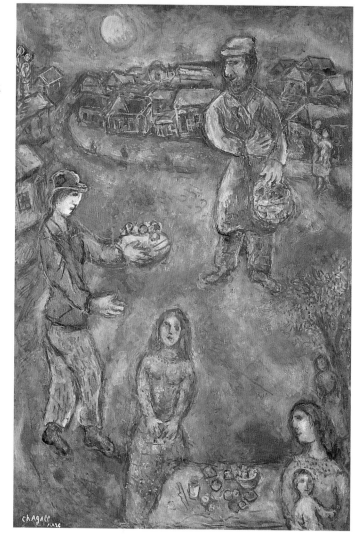

The Feast of Purim. 1973

his work, which included paintings, drawings, ceramics, sculpture, tapestries, and stained-glass windows—representing every period of his creative life.

The museum project

Four years later, in 1973, a new national museum was inaugurated in the South of France. Set on a hillside overlooking the city of Nice, it houses one of the artist's most impressive achievements, the biblical subjects—paintings, drawings, and sculptures—he had worked on over a period of 30 years, grouped together under the title "The Biblical Message of Marc Chagall." The same year, he painted *The Feast of Purim*, a lyrical evocation of the feast that marks the joyful Jewish holiday of Purim, which celebrates the triumph of Mordecai and Esther over the evil Hamen, as recounted in the biblical Book of Esther.

Sound Byte:
"It is not for me to talk about myself and my work. My aim was to get closer to the biblical homeland of the Jewish people, to the land where the creative spirit, the Holy Spirit, is at home."
—MARC CHAGALL

Return of a Russian

In 1973, Chagall was able to fulfill one of his dreams by returning, for the first time in more than half a century, to the land of his birth. Honored throughout most of the world, the artist had been practically ignored in the then Soviet Union (now Russia and other independent Eastern European countries). The occasion for his return was an official invitation by the Minister of Culture, who had organized an exhibition of Chagall's early work at an important museum in Moscow. It was a moving and often tearful experience for the painter, an opportunity to see once again his early work and to rediscover his roots. When he returned to France after the 11-day visit (which took him to Moscow and St. Petersburg—then called Leningrad—but not to Vitebsk), he felt elated and rejuvenated by this encounter with his past.

Reims

In 1974, the 87-year-old master of stained glass completed a demanding project at the Cathedral of Reims, in which many of France's kings are buried. After the preliminary work was done, Chagall painted the figures and shadows onto the surface of the windows in *grisaille* (i.e., a grayish underpainting used for sketches that will subsequently be overpainted). He called this triptych of windows the fulfillment of a dream he had cherished for 17 years.

A year later, he created the magical *Rest* (see page 65). The voluptuous

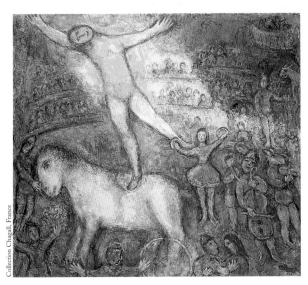

Collection Chagall, France

At the Circus. 1976

nude in the foreground, bathed in a glowing red light, provides the title for this tranquil piece. The small mountainside village at the center of the painting is a reminder of the small town in the South of France where the artist lived during the last years of his life.

During this period, Chagall frequently returned to the theme of the circus, which had delighted him when he was a younger artist. He was drawn to it by its colors, its movement, and its unique combination of joy and sadness, of danger and uninhibited pleasure. In *The Queen of the Circus* (1975) and *At the Circus* (1976), he brought to life in rich, vibrant colors the circus rider, a horse, a ballerina, animal-musicians, a bouquet of flowers, and rows of delighted spectators.

Busy guy

Chagall's 90th birthday was celebrated throughout the world in 1977. For the artist, it was an important and busy year: He received one of France's greatest honors, the Grand Cross of the Legion of Honor; he visited Italy and Israel; and he worked on stained-glass windows for the Art Institute of Chicago. Most significant, however, was another exhibition of his work at the Louvre in Paris, where 62 paintings executed during the previous decade, while he was in his 80s, were shown. They were acclaimed by critics as some of the artist's finest work, a brilliant testimony to his creative vitality.

Death of a master

In the years that followed, important exhibitions were held in Europe and in America, and a major retrospective, tracing each step of the artist's long career, opened in London in January 1985. On March 28, three days before the exhibition closed, Marc Chagall died at his home in St. Paul de Vence, France, at the age of 97. A poet-painter, he created for us a colorful world of floating lovers, flying cows, and fiddlers on the roofs—a world of fantasy and delight that guarantees his important role in the history of art and culture.